VALLEY COMMUNITY LIBRARY
739 RIVER STREET
PECKVILLE, PA 18452
(570) 489-1765
www.lclshome.org

LIGHT AND SHADE

A CLASSIC APPROACH TO THREE-DIMENSIONAL DRAWING

Mrs. Mary P. Merrifield

DOVER PUBLICATIONS, INC.
Mineola, New York

Bibliographical Note

This Dover edition, first published in 2005, is an unabridged republication of the sixteenth edition of the work originally published c. 1908 by George Rowney and Company, Artists' Colourmen and Pencil Makers, London, under the title *Handbook of Light and Shade, with Especial Reference to Model Drawing*. (Since the fifth edition of the work was published c. 1854, the first was published some time earlier.) The running heads reflect the book's original title.

Library of Congress Cataloging-in-Publication Data

Merrifield, Mary P. (Mary Philadelphia), 1804 or 5–1889.
 [Handbook of light and shade]
 Light and shade : a classic approach to three-dimensional drawing / Mrs. Mary P. Merrifield.
 p. cm.
 Unabridged republication of the sixteenth edition of the work originally published c. 1908 by George Rowney and Company, London, under the title: Handbook of light and shade.
 ISBN 0-486-44143-1 (pbk.)
 1. Shades and shadows in art—Technique. 2. Drawing—Technique. I. Title.

NC755.M4 2005
741.2—dc22

2004065744

Manufactured in the United States of America
Dover Publications, Inc., 31 East 2nd Street, Mineola, N.Y. 11501

CONTENTS.

			PAGE
The Preface	5
Introductory Remarks	7
Lesson 1.	General Principles	9
,, 2.	Of the Light under which objects are viewed, and of their Shadows	10
,, 3.	The Cube	16
,, 4.	The same (continued)	20
., 5.	The same	21
,, 6.	The same	23
,, 7.	The same	24
,, 8.	Aerial Perspective	25
,, 9.	The Prism and Inclined Planes	26
,, 10.	The Pyramid	29
,, 11.	The Cylinder	30
,, 12.	The Sphere	33
,, 13.	The Oval, or Egg Shape	36
,, 14.	The Cone	37
,, 15.	The Perspective of Shadows	39
Conclusion	42

PREFACE.

STIMULATED by the impulse given to art education by the establishment of the Department of Practical Art, and of Schools for Elementary and Model Drawing in connection with it, thousands of persons are now learning to draw systematically, where one formerly learnt. But there are thousands who, though desirous of learning, are unable to avail themselves either of private tuition or of the facilities offered by the State of attending the Government Schools. These persons have recourse to books for the art-education they would otherwise fail in obtaining. Manuals of linear-drawing, technical works on landscape and figure-painting, in oil and in water-colours, attest, by the numerous editions through which they have passed, the demand which exists for this description of literary labour, and the number of persons who are eager to take advantage of the facilities thus offered of cultivating the imitative arts.

Among the numerous works of the class referred to, it is believed that, though many give instructions for drawing correct perspective outlines of different objects, there is no work extant which expressly treats of the

Light and Shade incidental to these objects, and the method of giving them proper relief by this means.

The present little work is intended, in some measure, to supply this want, and the Authoress now offers it to the public, in the hope that the lessons contained in it will be found both useful and practical.

It may be necessary to mention that the instructions contained in the following pages pre-suppose the power of drawing correct outlines of common forms, and a knowledge of linear perspective.

INTRODUCTORY REMARKS.

THE proper distribution of the Light and Shade of an object, not to mention that of the whole picture, is always a subject of perplexity to the young student, and it is rendered still more so by the local colour of the object. Yet a little attention will show that Light and Shade are amenable to certain fixed laws, which may be as easily understood as the principles of perspective. The difficulty experienced by beginners, and that which sometimes renders the subject extremely complicated, lies in distinguishing what portion of the Light and Shade discernible on an object is to be considered as actually belonging to it, and without which it would be impossible to distinguish its form, and that which is entirely owing to reflection, received from the surrounding objects. On the just discrimination of these points depends the power of giving on a flat surface a true representation of an object. The pictorial arrangement of the Light and Shade requires the exercise of a larger amount of skill, and a knowledge of what painters call

" effect " ; upon this part of the subject it is not now proposed to treat. The observations contained in the following pages will be limited to a concise explanation of the principles of Light and Shade as developed by common daylight, by sunshine, and by candle or artificial light, upon single geometrical solids, and of the extent to which this Light and Shade is modified by reflection. As these objects will be best and most easily attained by the aid of illustrations, they will be elucidated by numerous drawings on stone. The illustrations, however, are not intended to supersede the use of models; on the contrary, it is recommended that, while studying the general principles here laid down, they should be verified in every case by reference to the white models. These should be set up for the purpose in a convenient situation, and should be studied under a proper light.

LIGHT AND SHADE
A CLASSIC APPROACH TO
THREE-DIMENSIONAL DRAWING

PLATE 1.

Light	Half Light	Middle Tint	Half Dark	Dark

FIG. 1.

FIG. 2.

A B

A B

FIG. 4.

FIG. 3

HANDBOOK

OF

LIGHT AND SHADE.

LESSON I.

GENERAL PRINCIPLES.

FORM is developed by means of light and shade; without these every object would appear flat.

All colour is a deprivation of light; therefore, if several objects of the same shape, some of which are coloured and some white, are situated similarly with regard to the light, the white objects will be lighter than the coloured ones.

Every solid opaque body has one part on which the light is brightest, and one part on which the shade is strongest, the other parts being of an intermediate tint.

The intermediate tint is called the middle tint, because it is equally removed from the extreme light and the extreme dark.

The intermediate tint may be subdivided into the half light, the middle tint, and the half dark. (Fig. 1, Pl. 1.)

The middle tints occupy the largest portion of the object, the extreme light and dark being limited to a very small space.

The brightest part of an object will be that on which the light falls directly.

The brightest part is called the high light.

The shadow side of an object will be that which is opposite to the light.

The shadow side is not synonymous with the shadow.

The extreme dark of a rectilinear object will be found generally close to the extreme or high light.

The shadow thrown by a white object is darker than the darkest side of that object.

In an opaque solid bounded by circular lines the extreme light will be found a little distance from the edge on the light side, and the extreme dark a little distance from the edge on the dark or shadow side, while on the intermediate part, the shade will melt gradually into the light.

LESSON II.

OF THE LIGHT UNDER WHICH OBJECTS ARE VIEWED, AND OF THEIR SHADOWS.

Objects are viewed under three kinds of light, namely, sunlight, ordinary daylight, and artificial light; and the effect varies according as they are seen under one or other of these lights.

As a general rule, the brighter the light the stronger and more distinct is the shade; in ordinary daylight the shadows are less distinct, and in dull weather they are scarcely visible.

When lighted by a single light, opaque objects can

be illuminated on one part only; the space situated on the side not lighted is said to be *in shadow*; the space on the ground, or on another object from which the light is obscured by an opaque solid, is called *the shadow*.

Shadows are analogous in form to the body by which they are cast; thus the shadow of a perpendicular is a straight line, the shadow of a rectilinear figure is rectilinear, that of a sphere is circular.

The shape of shadows is discernible only on their outlines, and is modified by the form of the surface on which they are thrown.

In sunlight the source of illumination (the sun) is at so great a distance, and of such magnitude in comparison with the objects lighted by it, that the luminous rays which fall on our globe are supposed to be parallel, and as such they are always to be treated in daylight scenes. The higher the source of light, the shorter will be the shadows; thus, at morning and evening, when the sun is low, the shadows are long, while as the sun rises the shadows become shorter, and are shortest at noon. In summer, when the sun attains greater altitude, the shadows at noon are not so long as at the same hour in winter, when the rays strike more obliquely and the sun is nearer to the horizon. There are certain places within the tropics at which the sun is sometimes vertical, so that if at noon a stick be set upright in the ground it will cast no shadow.

Where several straight lines are parallel to each

other the shadows thrown by these lines upon a horizontal plane will also be parallel to each other, and the perspective representations of these shadows will converge towards the same accidental points as the perspective representations of the lines themselves. (*See Lesson* XV.)

If the shadow thrown by a solid object is intercepted by other objects, such as a fallen tree or pillar, a wall, or a house, it is carried along the surface of these objects, and is terminated by the ray which, proceeding from the seat of light, touches in its passage to the ground the upper edge of the body which throws the shadow. In Fig. 2, Pl. 1, the shadow of the cylinder or tower is cast first upon the ground, then, ascending the wall of the house, it crosses the roof, where it terminates. The oblique line, A B, shows the direction of the ray of light.

The perspective of shadows will be treated in a subsequent lesson.

From artificial light the rays diverge equally all round.

If more than one artificial light be present, objects will have as many shadows as there are lights; and, as these shadows frequently intersect each other, it becomes very difficult to distinguish their true shape, and, consequently, to represent them. The same thing takes place, but in a lesser degree, in the day-time, when the light is admitted by more than one window; in the latter case, however, the light being more equally diffused, the effects of the cross-lights are not so pal-

pable to the casual observer. Objects seen under these circumstances also want that lucid and intelligent arrangement of light and shade, and breadth of effect, which are essential to pictorial representations. It will be understood, then, that when objects are to be represented in light and shade, they must be illumined by one light only.

We have now to speak of the situation of the light. When the sun is the illuminating body, it is always above our heads, and the shadows are in consequence thrown downwards. This, which is the natural, is also the most agreeable disposition of the light, as well as the most convenient. It is imitated by painters, who close up the lower windows of their studios, admitting the light only from above.

In an out-door effect the sky will be the brightest part, in an in-door effect the brightest light will fall on the floor.

Independently of its height, the situation of the sun with regard to the spectator is continually changing. It may be on the right hand or the left, before or behind him. If it be behind him, the illuminated side of objects will be presented to him, and will want shadow. If it-be before him, the shadow side of the objects will be next to him, and the picture will want light. If, on the other hand, the place of the sun be more or less either on the right or the left, there will not only be bright light and extreme shade, but a breadth of middle tint, the most favourable conditions for making a picture. It will be understood that these remarks do

not apply to landscape painting, particularly with re-
spect to sunsets, in which the light is in the sky, and
the shadow side of objects is turned towards the spec-
tator.

From the above observations it will be apparent that
the choice of a proper light is a subject of great im-
portance to the painter.

The terms breadth and repose have been mentioned
in these pages, and, as they frequently occur in works
of art, it will be proper to explain them.

By breadth is meant the introduction into the picture
of large masses of light and shade, in contradistinction
to a number of small lights, which distract the attention
of the spectator, and break up the effect.

When the masses of light and shade are harmoniously
arranged and balanced, the effect of repose is ob-
tained.

The preceding observations should be carefully
studied, and their truth tested by close observation.
When they are become tolerably familiar, the student
may proceed to draw from models. These should be
white in colour and without polish. The most simple
of the geometrical solids should be selected, the recti-
linear figures first, and then the curvilinear. Of this
kind are the cube, the parallelopiped, the prism, the
pyramid, the cylinder, the sphere, the egg, and the cone.
As these solids are not supposed to be suspended in the
air something must be placed under them by way of
ground. The ground may be either white, of a middle
tint, or dark, but it should not have a shining surface.

As the models are not placed in a vacuum, they must have a background placed at a small distance behind them. This, also, may be either white, of a middle tint, or dark, but the surface should be of one uniform colour, and not polished. Neither should it be creased or folded. A sheet of white pasteboard, or tinted drawing board, or a black board will answer the purpose extremely well. The colour of the background should be frequently changed, and the same model should be set before different backgrounds, and the different effects carefully noted, until the student is become so familiar with them that he could draw them almost from memory.

In order to study the effects of light and shade which actually belong to the model from those which are produced by reflection, before beginning to draw, another precaution is necessary, namely, to remove to a distance all objects that will either intercept the light from the model, or cast reflection upon it.

Let the student now proceed to study from the solid object, and " set the model " — in the present case a cube —in the manner described in the lesson, then taking his seat at a moderate distance, let him, after a careful examination, make as good a copy of it as he can, and with as much expedition. He must recollect that " time and tide wait for no man," that while he is thinking what to do the sun is travelling his daily journey from east to west, and that the shadows change more rapidly than he can transfer them to paper. Two hours is the utmost limit of time for one sitting before a model; less

would be better.　If the drawing is interrupted before it is completed, or if it could not be completed at one sitting, when again resumed it should be at the same hour, and under the same arrangements with regard to the admission of the light and the disposal of the background.

From the foregoing observations it will be seen that it is very desirable to acquire an expeditious manner of working; and, in drawing from models, it is better to aim at obtaining a good effect than at making a highly finished drawing.　If a true effect be produced, the drawing may be worked up at leisure, or, what would be infinitely preferable, the original may be left, and a finished copy made from it.　As a general rule, a sketch from nature should never be touched after being completed.

The materials may be tinted cartridge paper of various colours, the smooth side of which should be used, and black and white chalks.　Chalk is preferable to pencil because it does not shine.

LESSON III.

THE CUBE.

Fig. 3, Pl. 1.　In this figure the cube is placed on an ordinary table, in a direct line with the course of the light, which enters by one window from which the sunshine is excluded, the lowest edge of the window being a few inches above the table.　The cube stands upon a piece of dark common pasteboard.　A sheet of white

drawing board is set up at some little distance behind to serve as a background. This is one of the most simple conditions, as regards light and shade, in which an object can be represented. The side next the light is that which is most exposed to its influence, it is therefore in high light; the top is less brilliantly illuminated than the side, though it still receives light from the window. The background is of a light middle tint. The square side next the eye is in half shadow, or half dark, the ground on which the cube stands is still darker, while the shadow thrown on it by the cube is darkest of all; this is therefore the extreme dark. It will be observed that the extreme light and the extreme dark make up but very small portions of the picture, the principal part consisting of the middle tints. So far the gradations of light and shade are evident even to an unpractised eye. I now proceed to notice the gradations which are less evident, and which, in fact, are rarely discernible, except by an eye to which long observation has given greater powers of perception. It is the power of distinguishing these minor, and, to the casual observer, imperceptible gradations, which constitutes the artist, and these powers are always most clearly developed in those who are the closest observers of nature.

Pupils at first find much difficulty in distinguishing them, even when pointed out by their instructors, but their powers of observation may be much strengthened and improved by the knowledge of a few simple laws of optics.

We have said that nature has no other means of distinguishing solid objects than by light and shade; a light object, for instance, is contrasted by a dark, and a dark by a light one. Now, let us see how this bears upon the subject before us. The white background behind the white cube is so nearly of the same tint as the model, that were it not for another law of optics we should have some difficulty in relieving the cube from its ground. It is found, therefore, that :—

In order to give greater force to a brilliant light, it appears to be bounded by dark, which though apparent to the eye, is, in fact, known not to exist, but which must have a place in the picture in order to give a true representation of the object. Let the reader now look at Fig 3. The background, which we have said was white, is here represented shaded. The dark tint against the high light does not really exist, but is the effect of contrast with the bright light. To prove this, let the student hold up his pencil (first shutting one eye) in such a manner as to hide the high light, when the dark on the background which met it will be no longer visible, but on removing the pencil it will again appear. Now let us look at the shadow side of the cube. Here also there is a shadow on the background, but in the first case the dark is brought closely and firmly up to the light, whereas, in the present instance, a light appears between the dark side of the cube, and the shadow on the background. In the first case, the dark is an optical illusion, in the second, the light is an optical illusion. The second case is to be proved like

the first, by holding up the pencil so as to hide the cube, when it will be seen that the background is, in fact, of the same uniform tint, and that the light and shade are the effect of contrast; the light on the background next the dark side of the cube is necessary to give it relief, and separate it from the ground. Although these effects do not really exist in nature, they must form a part of every true pictorial representation of it; for *the great object in painting is not to represent objects as they really are, but as they appear to the eye to be.* This may be further illustrated by reference to the law of contrast discovered by M. Chevreul, namely, " When two tones of the same colour are juxtaposed, the light will appear lighter, and the dark darker than it really is."

Let the pupil now take two sheets of paper of the same colour, but of different tones, that is, one darker than the other, and cut them in two. Let the light be called A.A' (Fig. 4), and the dark B.B'. Place A.'B.' close together on a white wall, an A.B. at a little distance on the same wall, A.' near A., and B. near B'. On retiring to a distance it will be seen that A.' appears lighter than A., and B.' darker than B., and that the contrast is greatest at the edge where A.' and B.' join. But this is not all, the white background will appear of a more brilliant white between and around B.B.' than in the corresponding space between A.A.'

Returning now to the cube, it will be observed that the dark on the side next the eye is most intense where it meets the light. This gives firmness and great relief.

The moonlight sketch, Fig. 1, Pl. 2, which was from recollection, will afford another illustration of the effect of contrast. When the finger was held so as to conceal the moon, at the time the effect was observed, the cloud on the horizon was seen to be of a uniform tint, instead of being darkest under the moon, as represented in the sketch, but the dark tint appeared again on removing the finger.

We shall here give another illustration, for which we are also indebted to M. Chevreul, of the effects produced by contrast. Fig. 2 represents ten gradations between white and black. Each gradation occupies the same space, and the darkest part of each shade appears to be at the edges where the darker unite with the lighter shades. If a hole be cut in a piece of paper the size and shape of one of the gradations, and laid upon it, it will be seen to be all of the same tone or degree of darkness; the apparent darkness at the edge is therefore merely the effect of contrast. There is also another peculiarity attending this figure, namely, that it appears to represent a grooved surface like that of a fluted pillar. It is necessary to be aware of the deceptive nature of these appearances in order to represent them correctly.

LESSON IV.

THE CUBE (CONTINUED).

Fig. 3, Pl. 2. Now, without removing the cube let us change our seats, so that we see the side furthest from

PLATE 2.

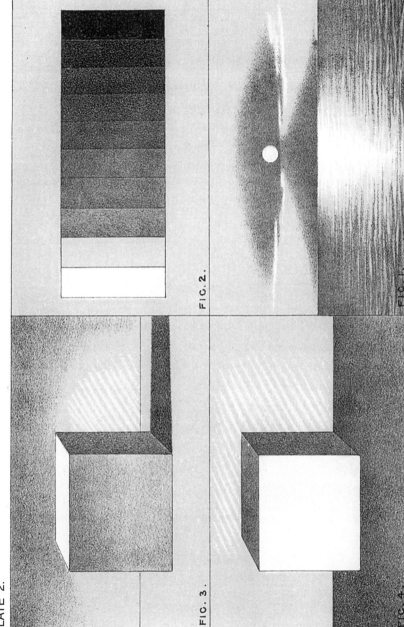

FIG. 2.

FIG. 1.

FIG. 3.

FIG. 4.

the light and opposite to that which was most strongly illuminated in Fig. 3. The top receives the high light, the side next the eye is still in half shadow, and the third side is darker than the second, while the shadow on the ground represents the extreme dark. It will also be observed that the side next the shadow is darkest where it meets the square side, and that the latter is lightest at the point of meeting, and darkest where it cuts the light top and the background. According to the rule of M. Chevreul, exemplified in the last lesson, there is another reason why the shadow side is darkest where it meets the square, namely, because this part is nearer to the eye of the spectator; for it is another law of optics that shadows are strongest near the eye, and that they decrease in strength and intensity in proportion to their distance. This is the first rule of aerial perspective.

In order to relieve the cube in Fig. 3 from the white background, the latter must be represented of a middle tint where the high light comes against it, and it must be made very light where it meets the shaded sides of the cube, the light on the background next the darkest side of the cube being equal in brightness, though not in extent to that on the top of the cube.

LESSON V.
THE CUBE (CONTINUED).

Fig. 4, Pl. 2. A cube, of which the square or principal face or side is placed broad to the light, the place of the student is to the right of the cube, with his back to the

light. Here it will be seen that the first gradation of shade is on the top, the second on the side which recedes from the spectator, while the ground represents the dark. In this view the shadow thrown by the cube is not visible, because it is cast on the side opposite the spectator, and behind the cube. In order to relieve the dark side from the ground on which it stands, this side is made a little lighter near the ground, according to M. Chevreul's rule (*p.* 18). This side is darkest where it meets the light, and on that part which is nearest the spectator—in this case both points are identical. In order to detach it from the background, the latter is made lighter round the shadowed side of the picture, the light being brought up close to the shaded parts and blended off gradually, while the portion of background which comes against the edge of the square in high light is left of a middle tint; without this arrangement it would not be distinguishable, nor would it have proper relief.

The student is now requested to compare the three cubes, when it will be seen that in the first two the light is introduced on the side of the object; but, in the other, the light falls full in front of the cube. The first arrangement is infinitely preferable, not only because it is more agreeable to the eye, but because it enables us to introduce a small portion of extreme dark in the shadow.

The first arrangement also enables us more easily to produce the qualities called *breadth* and *repose*, by means of large masses of middle tint.

LESSON VI.

THE CUBE (CONTINUED).

Fig. 1, Pl. 3. In the three preceding views of the cube, the figure was placed upon a dark ground; we shall now place the first and second figures on a white ground, in order to show what effect this has upon the general light and shade. The principal difference occasioned by the white ground is that the lower part of the square side, which faces the spectator, is lighted up by reflection from the white ground, and that it is, consequently, darker at the top than the bottom. There is a strong light on the ground adjoining the bright light on the side; this, also, is partly due to reflection. The same remarks occur, also, with regard to the second cube on the white ground, Fig. 2. The principal difference is that in the latter the shadow on the ground is lighted up in the middle by the reflection of the side in shadow and the ground.

This leads us to observe, that the light and shade of objects are modified, not only by the position in which they are placed with regard to the light, but also by reflection.

We also learn that the darkest parts of shadows are on their edges; the middle being lighted up by reflection from surrounding objects.

LESSON VII.

THE CUBE (Continued);

Figs. 3 and 4, Pl. 3. In the preceding examples, a white background has been placed behind the cube; it will now be changed for a black one, and the model will also be placed on a dark ground. In the former case the principal shades were on the object, in the present they are on the ground and background, for the part which in the first appeared dark, when contrasted with the light background, now appears light middle tint contrasted with the dark background. In other respects the same general principles prevail; a little light is reflected from the light side of the cube on the dark ground on the side next the light. A stream of lighter tint also separates the dark shadow on the ground from the darker background, and the shadow itself is lighted up by reflection in the centre. The last two figures represent a light object against a dark background; the first five a light object upon a light background. There are no other means found in nature by which objects can be relieved.

These cubes also serve to illustrate the axiom, that that light appears brightest which is surrounded by the greatest quantity of shade. To be satisfied of this truth, it is only necessary to observe how much brighter the last two figures appear than the others. It is on this principle that dark backgrounds are so frequently put to portraits; the contrast of the flesh tints with the dark ground which surrounds them gives great brilliancy to the former.

PLATE 3.

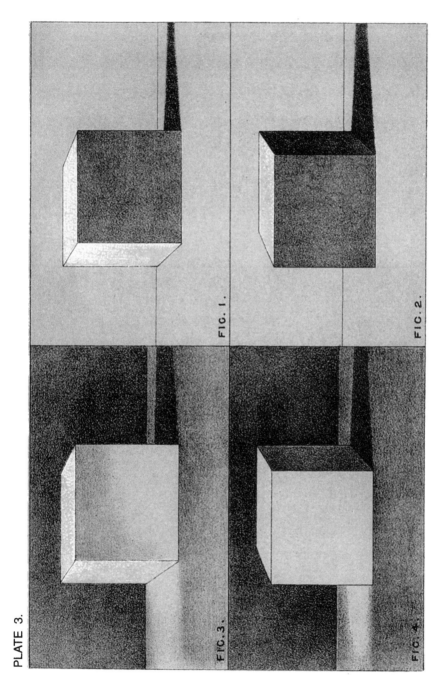

FIG. 1.

FIG. 2.

FIG. 3.

FIG. 4.

LESSON VIII.

AERIAL PERSPECTIVE.

The parallelopiped so nearly resembles the cube, in its effects of light and shade, that it is unnecessary to give separate figures of it. There is, however, one observation with regard to this figure that it will be important to notice.

It frequently happens that a long range of buildings, or a street, or a flat pavement situated at right angles or obliquely with regard to the spectator, has to be represented. Now, as the rays of the sun, from the immense distance of the seat of light, are supposed to be parallel, they will strike with equal force along the whole range of the building or street, yet if we were to represent the building or street along its whole range as equally illuminated or equally obscured, we should do wrong. Objects not only decrease in size by distance, but, by the intervention of the atmosphere, become less distinct, and the further they are removed the more they are influenced by the atmosphere. This is particularly observable in towns, and in the morning, when the haze is frequently so great as to assume the character of a fog. As the general colour of the atmosphere is supposed to be blue, distant objects lose much of their local colour, and assume more or less of a grey tint, and the details become less distinct, until they are totally lost in the distance. This effect can be easily represented with colours, but with chalk or pencil it is different. The effect has to be rendered by means of light and

shade only, and the student must endeavour, in looking at nature, to separate these from colour. The effect of the atmosphere which envelopes the object will be to make the shades of distant objects appear lighter, and the lights of objects equally illuminated by the sun less vivid; therefore in representing a long range of build-ing, or wall, or flat pavement, which retires from the eye as in sunshine, a light shade or tint will be passed over the more distant part, and gradually lost in the light as it approaches the eye. For the same reason, if the building is to be represented as in shadow, the shades will be stronger near the eye, and the more dis-tant parts seen through the vapour will be fainter. It must, however, be distinctly recollected, that lights are less modified by distance than shadows.

The same effect takes place with regard to the repre-sentation of ground retiring from the eye, the more dis-tant parts of which are less distinct. It will be under-stood once for all, that in all these cases, objects are supposed to be equally illuminated, and not seen under those transient effects common in showery weather, by which one part is strongly illuminated, while the rest is enveloped in shade.

LESSON IX.

THE PRISM AND INCLINED PLANES.

Fig. 1, Pl. 5. Triangular prism. If the previous observations upon aerial perspective have been under-

PLATE 4.

FIG. 1.

FIG. 2.

FIG. 3.

PLATE 5.

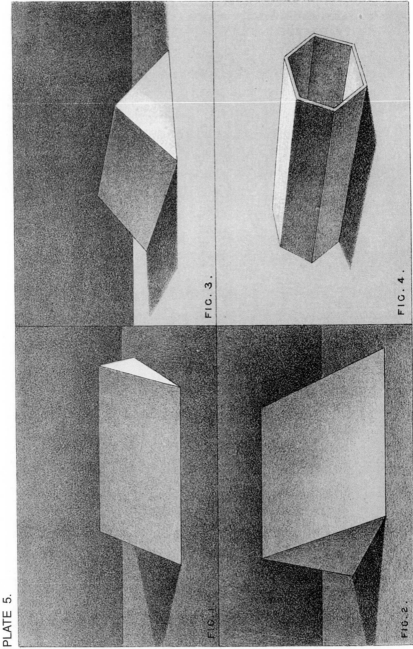

FIG. 1.

FIG. 2.

FIG. 3.

FIG. 4.

stood, there will be little difficulty in shading this figure. The light in this plate on the right hand falls on the triangular end : the shadow on the opposite side raises the figure from the ground. The shadow is triangular in shape, and darkest at the edges; the strongest part of the shadow is that which is nearest the eye.

On the inclined plane, which is in half light, a little shadow will be perceived, beginning at the extremity, or most elevated part, and blending gradually into the half light, or middle tint, as it approaches the eye. The object of this is to represent the change effected in the appearance of the object by its inclination with regard to the eye of the spectator. If the parallelogram had been vertical (as in the cube), there would have been no shadow; had it been laid flat on the ground, the more distant edge would have been further removed from the eye, and, in consequence, more shading would have been necessary to make it look flat; in its present state it is intermediate, and only a small quantity of shade is necessary to give it a proper elevation. From these observations it will be understood that the higher the inclined plane is raised, the less shading will be required, and the flatter it is, the more it must be shaded.

In Fig. 2 the inclined plane is steeper than in Fig. 1, and the shadow side is visible instead of the light.

The darkest part of this side is that which joins the light, especially at the lower angle, which is next the eye, and the other edges of the shadow side appear light by contrast with the dark background.

Fig. 3 is another view of the prism. In this figure

one of the long sides is in shadow, and the upper ridge terminates with a line of light where it cuts the background; below this is the shadow, which is darkest where it meets the triangular end. The lightest part of the triangular end is next the shadow side of the parallelogram.

Fig. 1, Pl. 6. A hollow octagonal prism, as seen by a person standing opposite one of its sides. The three sides next the eye will be easily represented by attending to the foregoing rules. The five other sides, as seen from within, will require a little explanation. The two next the light are shaded a little at the top next the white rim; the middle is crossed diagonally by a triangular shadow, which, however, as it is more distant, must not be so dark as the shading on the side nearest the eye. The other two sides, being opposite the light, are strongly illumined, especially at the top.

Lower down they are a little darker, in order to give relief to the light edge. The shadow touches three sides in the present position of the prism.

Fig. 4, Pl. 6. A hexagonal prism of pasteboard lying obliquely on its side. The high light is on the side that is lying upwards. Next to that is the darkest side, the darkest part of which is on the end nearest the eye and on the edges; it is lighter at the more distant end. On the third side is a strong reflected light, thrown on it by the white ground. The shadow joins this side, and the extreme dark is along the line of junction. The shape of the shadow must be carefully expressed. The further end of the prism is relieved from the ground by a little bright light.

PLATE 6.

FIG. 3.

FIG. 1.

FIG. 4.

FIG. 2.

PLATE 7.

FIG. 1.

FIG. 2.

FIG. 3.

FIG. 4.

We now return to the end next the spectator. There is a little shadow, softened upwards from the edges of two sides, and a dark outline to the third. They are relieved by the bright light on the ground. A little shadow also marks the lines dividing the sides. The side on which the figure is lying has a triangular shaped shadow, strongest at the further part; the light falls on the other part of this side. The peculiar effect of this figure is owing to its semi-transparency.

LESSON X.

THE PYRAMID

Fig. 3, Pl. 6. The sides of the pyramid are inclined planes, and as such they must be treated, observing, however, to put less shadow on the top of the pyramid than on the inclined plane, because the vertex of the pyramid, diminishing to a point, occupies but a small space, in comparison with the mass of dark by which it is surrounded; it will, therefore, look much lighter than it really is, and, to obtain a true effect, it must be so represented. A little shadow will be required on the edge next the light of the side in middle tint, to give vigour to the high light, and to make the other edge, which cuts the dark background, look sufficiently light, and stand out in proper relief.

Fig. 4. The same remarks apply with little

variation to the lower pyramid. The front is now in middle tint, and the other side in shadow. To give proper relief, a little light must be added on the edge next the shadow side, which must be darkest next the light edge.

LESSON XI.
THE CYLINDER.

Pl. 7. The figures hitherto described are rectilinear, those now to be represented are bounded by curved lines. We shall begin by the cylinder, the outline of which consists partly of straight lines, partly of curves. It may be useful to compare the octagonal prism with the cylinder. In the former, it will be seen that neither the extreme light nor the extreme dark is on the edge of the figure, but both are situated near the junction of the sides with the centre face; the extreme edge on the one side is not so light as the high light, the extreme edge on the other side is not so dark as the extreme dark. The reason for both is the same : the outer edges of these planes are not only further removed from the eye of the spectator, but they receive the light obliquely, and therefore they are neither so bright nor so dark as the nearer edges.

The same thing takes place, in a less marked degree, in the cylinder, the surface of which, being round, affords no sharp contrasts of light and shade, as in the hexagonal or octagonal prism. The extreme light and

the extreme dark in both are situated at a small distance from the edge on each side. The place of the extreme light and extreme dark varies according to the light under which the figure is viewed.

When the light enters on the left hand, so that the shadow is parallel with the horizontal line, the spectator being placed on the left of the figure, the extreme light and extreme dark may be arranged as in Fig. 1, namely, a little removed from either edge. From these two extremes, both light and shade radiate on each side, until they unite almost imperceptibly, and produce the effect of roundness.

The space *beyond* the extreme dark is called the reflected light; this is frequently warmer in colour than the rest of the figure.

Fig. 2. When the cylinder, placed as above, is viewed by a person standing opposite to it, the extreme light is closer to the edge, the extreme dark near the centre; by this arrangement more than one-half of the figure is in shadow.

The further the spectator removes towards the right, the further does the extreme dark appear to advance, till at last it will assume the appearance of Fig. 3.

Let us now place the cylinder on a sheet of white paper, and set up a dark background behind it. The spectator, being seated to the right of it, will see it as in Fig. 4. The effect of the dark background is to make the reflected light on the shadow side appear stronger; and the effect of the white paper on which it stands is to reflect on the lower part of the cylinder,

which it lights up ; while the extreme dark, instead of extending from the top to the bottom, nearly disappears before it reaches the bottom. Another variation is occasioned by this arrangement ; the dark shadow thrown by the cylinder on to the white paper is also reflected upwards, or perhaps, we should say that no light is reflected on the cylinder immediately adjacent to the shadow ; consequently there is a little more shadow on this part of the cylinder than the other.

The light reflected on the top of the cylinder is strongest on the part next the shadow side of the cylinder.

To draw the shadow, begin by sketching the shadow of a cube, and within that draw part of an oval, which is the required shadow. Do not forget to make it lightest in the middle, and darkest next the eye.

Fig. 1, Pl. 8, is a cylinder, whose longest diameter is lying parallel with the spectator ; the end receives the light. In Fig. 2, the figure lies obliquely, the end being next the spectator. This is now dark. Here the contrast of light and dark is distinctly seen in every part, also the difference in the intensity of the shadow between the part nearest the eye and that which is most distant. The similarity in the arrangement and distribution of the light and shade between this figure and the hexagonal prism cannot fail to be observed. The difference is sufficiently accounted for by the rounded surface of the one and the angularity of the other, which occasions some decided contrasts of light and shade.

The chief difficulty lies in imitating exactly the re-

PLATE 8.

FIG. I.

FIG. 2.

FIG. 3.

FIG. 4.

PLATE 9.

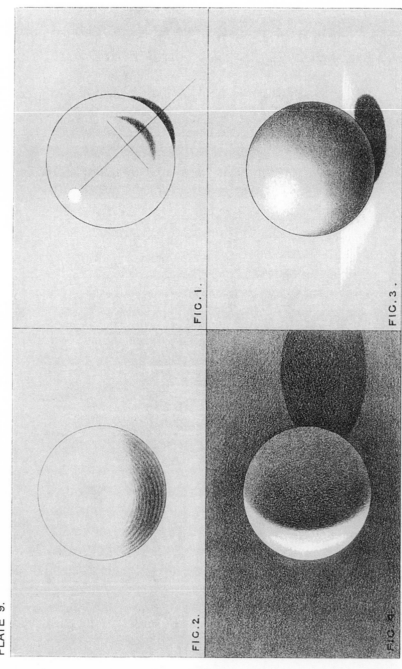

FIG. 1.

FIG. 2.

FIG. 3.

FIG. 4.

flected light. When seen against a dark background, it is more vivid than when opposed to a light one, and in the first case it appears, by contrast, darker than it really is. As a rule, it may be considered that one-half of the figure is dark, the other light; and that how bright soever the reflected light may appear, it is always darker than the middle tint. The best method of determining the true tone of the reflected light will be to have recourse to our former experiment of holding up the pencil so as to hide the extreme dark, and, first shutting one eye, compare the reflected light with the shadow on the other side of the dark. It will thus be seen that there is no part of the shadow side of an object without some degree of shade. The true way, then, of beginning to shade a cylinder, will be as in the diagram. [Fig. 3.] If to this commencement, *on tinted paper*, the dark shade be added a little distance from the edge, and the white a little distance from the other edge, the effect of roundness will be attained. The reflected light will appear more brilliant, if contrasted by employing a dark background.

LESSON XII.

THE SPHERE.

Pl. 9. The surface of the cylinder, we have seen, is partly circular and partly flat; it is bounded by straight lines and curves; the peculiarity of the sphere is that every part of the surface is bounded by

lines equally curved; there is no part of it which can by possibility be called flat, and, in whichever way it is viewed, it presents on every side a perfect circle to the spectator. It follows, also, from these observations, that there can be no flat tints of light or shade, or sudden variations of tone on a sphere, and that the high light must be diminished to a round spot. It is necessary to bear in mind these properties of the sphere when drawing it, because the truth of the representation depends upon their being observed.

Having placed the sphere and arranged a suitable ground and background, begin by drawing a perfect circle. Next, settle the place of the high light, the extreme shade, and the shadow. The high light on a sphere is, as has been just observed, a circular spot from which the light radiates equally all round. The extreme dark is always opposite this light, and a diameter drawn through the high light to the opposite edge will pass through the middle of the extreme dark, which is always at right angles with this line. The form of the extreme dark is a curve corresponding, but a little way within the circumference of the circle. The same diameter will also divide into two equal parts the shadow thrown by the sphere on the ground or background; the place of the shadow, therefore, is opposite the high light, and parallel with the extreme dark. (*See* Fig. 1.)

The observations relative to the intensity of the reflected light on the dark side of the cylinder, apply also to that on the sphere. In drawing the latter

figure, it may be commenced as was recommended with regard to the cylinder, and as exemplified in Figure 2.

Fig. 3. A sphere on a white ground with a light background, seen by sunlight. The sun is very high, and the shadow consequently smaller than the sphere, and very distinct.

Fig. 4. A sphere floating on a dark background. The light is ordinary daylight and nearly horizontal. The figure is seen by a person standing some little distance to the right of it, so that the light resembles in form that of the moon in the wane. The extreme dark is nearly in the centre, and takes the curved form of the surface. The reflected light is strongly marked.

Fig. 1, Pl. 10. A sphere on a white ground, and with a dark background. The spectator is now placed on the left of the sphere, the light is more diffused, and the shaded part now assumes a crescent form, and is darkest in the upper part, the lower being lighted by reflection from the white ground. The bright light on the ground separates the shadow from the background, and a little shadow on the ground to the left of the sphere, gives relief to the light part of the ball.

Fig. 2. A sphere, floating on a dark background, and placed opposite the light, the spectator standing in front of it. The high light is now in the centre, and radiates equally all round, becoming fainter as it approaches the edges, until it is lost in a light shade

tint which gradually deepens until it reaches the edge, which unites softly with the dark background. In this view the shadow is behind, and, consequently, invisible.

LESSON XIII.
THE OVAL, OR EGG SHAPE.

The oval so far resembles the sphere that every part of the surface is curved, but the curves are not everywhere equal. It is longer in one direction than the other, and one end is frequently larger than the other. In the present case the large end is rounder, the small end more pointed.

When the oval is laid on its side, and the large end is presented to the spectator, the appearance is that of a sphere. The smaller end resembles rather the cone than the sphere.

Fig. 3. Let the oval be now set up on the small end on a light ground, and before a light background, and with a side light like the other figures, the spectator being placed towards the left. One half—the right half—of the figure will be covered with shade, becoming gradually lighter at each end, especially the lower end which receives reflected light from the white ground. The extreme dark is placed at a small distance from the edge, as in the cylinder, and its shape is slightly curved like the outline of the figure. The background being light, the darkest part of the general shade is towards the top. The high light is of the same shape as the

PLATE 10.

FIG. 1.

FIG. 2.

FIG. 3.

FIG. 4.

extreme dark, and is similarly situated on the opposite or light side.

Fig. 4. Now place the oval on a light ground, before a dark background, and observe the difference in the light and shade. The upper part of the figure is now the lighter, and the extreme dark is on the lower and more pointed end, the lowest part being the darkest, whence the shade becomes gradually fainter as it rises, until at last it is nearly lost in the light at the upper end.

LESSON XIV.

THE CONE.

Fig. 2, Pl. 11. When the cone is placed upright (*i.e.*, with the vertex pointing upwards), the general treatment as regards its light and shade will be on the principle of the cylinder, with this difference, that the extreme dark is most intense at the vertex, and from this point it gradually becomes lighter, and increases in width. The stream of high light, which is at some distance from the edge, is equally intense throughout its length, and diffuses itself gradually in a pyramidical form, spreading at the base, and tapering towards the vertex. Were it not for the contrast with the strong dark shade from the vertex and the dark background, the light would be less brilliant towards the vertex, because this part is further removed from the eye, but on account of this contrast it appears more brilliant than it really is.

When the cone is placed on a white ground, and before a dark background, the form of the shade receives a modification by the reflection of the white ground on the lower part. Fig. 3 represents a cone thus situated, as seen by a person placed in front of it. The extreme shade is now nearly in the centre, darkest at the top, and considerably lighter as it approaches the base. The light is smaller in quantity, but its form is unchanged. A little bright light on the ground, to the right of the figure, helps to relieve it from the ground and to define the shadows ; the background is darker on the left, in order to give effect, by contrast, to the light.

Fig. 4. When the vertex of the cone is presented to the spectator, the outline of the figure is circular, and there is a bright spot of light in the centre, from which radiates a stream or line of light towards the circumference, its intenseness diminishing in proportion to its distance from the centre. In a similar manner two streams of intense dark radiate also from the centre, and these two lines of dark, with the line of light, divide the circle into three equal parts. The space between the two lines of extreme shade is dark, but the shade is strongest at the centre, whence it gradually diminishes towards the circumference, where it meets the dark pyramidal shadow. On the other side of the two dark lines (radii) the shadow diminishes rapidly in intensity, until it loses itself in the light, and the light, gradually increasing in brilliancy, is at last concentrated in the stream of high

PLATE 11.

FIG. 4.

FIG. 2.

FIG. 3.

FIG. 1.

light. Turning now our attention from the distribu-
tion of light and shade just described, another arrange-
ment may be observed, which, however, is subservient
to the first, namely, that one half of the circle appears
to be in shade, and the other in light.

The shadow is pyramidal, somewhat lighter in the
middle, and strongest at the point nearest the eye.

When the ground is white, a little shade tint will
be found where the light part of the cone meets the
ground; without this there would be no relief.

LESSON XV.

PERSPECTIVE OF SHADOWS.

Pl. 12. Although the shape of the shadows thrown
by several of the figures has been incidentally men-
tioned in the course of these pages, yet the little work
would be incomplete without a few directions for the
projection of shadows of rectilinear objects, as well by
sun-light as by candle-light. This subject should
properly be included under the head of perspective;
but, as it is seldom treated in elementary works, a few
of the more simple and obvious examples, with the
rules they are intended to illustrate, are now added in
the hope that they will be found useful.

"When the sun is in the same plane as the picture,
that is to say, when the picture is so placed that if it
were continued indefinitely it would cut the sun in
the centre, the direction of the shadow of a vertical

line on a horizontal plane will be a line parallel with
the horizon, and the luminous ray which touches the
top of a vertical line will determine the length of the
shadow."

Fig. 1. In the present example the sun is on the
left of the picture, as is evident from the front line of
the shadow being horizontal. The rays fall in the
direction of the line A B. The ray which touches the
upper angle of the object C meets the ground at B, and
is the limit of the shadow in that direction. B and C
are parallel, and their extremities converge, like the
retiring lines of the figures, in the point of sight. This
is the most simple distribution of light and shade, as
well as one of the most effective, and as such it has
generally been selected in this little work for the exam-
ples of model drawing.

Fig. 2. When the sun is in front of the spectator
proceed as follows :—Draw the horizontal line and point
of sight P, and draw in perspective the object O, whose
shadow is to be defined. Mark a point S, which is to
represent the sun high above the horizon, from S drop
a perpendicular B to the horizontal line. From S draw
lines of an indefinite length through the upper angles
A, C, D, of the object O. From B draw lines through
the lower angles a, c, d, of the object O. These last
three lines will intersect the former in 1, 2, 3; draw
1, 2, parallel with the base line of the object a, c, and
2, 3, P, to the vanishing point of C, D, c, d. The
shadow is bounded by the lines a, c, d, 3, 2, 1, a.

The rule is as follows :—

" When the sun is behind the plane of the picture, as in the present case, the direction of the shadow thrown by a perpendicular line upon a horizontal surface, has for its vanishing point the foot of the perpendicular, dropped from the centre of light upon the horizon; and the luminous ray, which passes from the centre of light to the top of the perpendicular line, whose shadow is required, always determines the length of the shadow."

Fig. 3. If the place of the sun is behind the spectator, and consequently in front of the picture, the place of the sun must be below the horizontal line, instead of above, as in the former example. Now draw the horizontal line, the point of sight P and the solid object O. S represents in this figure the place of the sun as it did in the last, but it is now below the horizontal line instead of above. Raise a perpendicular to B on the horizontal line. Now proceed to draw the shadow as in the last example, by drawing lines from the upper angles A, C, D, of the object O to S, and from the lower angles, A', C', D', to B. These lines intersect each other in a, c, d. From a, through c, a, a line is drawn to P, as the vanishing point of the side A, C. Draw a horizontal line through c, d, as the furthest line of the shadow. The direction of the line c, d, will be more apparent the further P is removed to the left of B.

We have now to speak of candle-light shadows. For the reasons before mentioned, the higher the light is placed the better will be the effect.

In the following example objects are placed all round a candle. Lines are to be drawn from the candle S, touching the upper corners of the objects. A perpendicular is then to be dropped to the foot of the candlestick. Lines drawn from this point, touching the lower angles of the objects, will intersect the former lines, and so give the true shape of the shadows. This process, it will be observed, is like the other; the difference is in the respective size of the luminaries, the rays of the sun, from its immense magnitude, appearing parallel, while the candle, from its small dimensions, admits of objects placed all round it being seen simultaneously. It is almost unnecessary to observe that the objects must be first drawn in perspective. The point of sight in the following figure corresponds with S.

CONCLUSION.

If the preceding examples have been carefully studied, the learner will have become familiar with the light and sháde incident to the more simple geometrical solids, from which all other forms are derived. They are, to the painter or draftsman, what the letters of the alphabet are to the writer—the observing eye detects them everywhere, and under all disguises.

It may be as well to mention a few of these derivative forms, partly by way of explanation, and partly with a view to suggest to the student future objects of study.

PLATE 12.

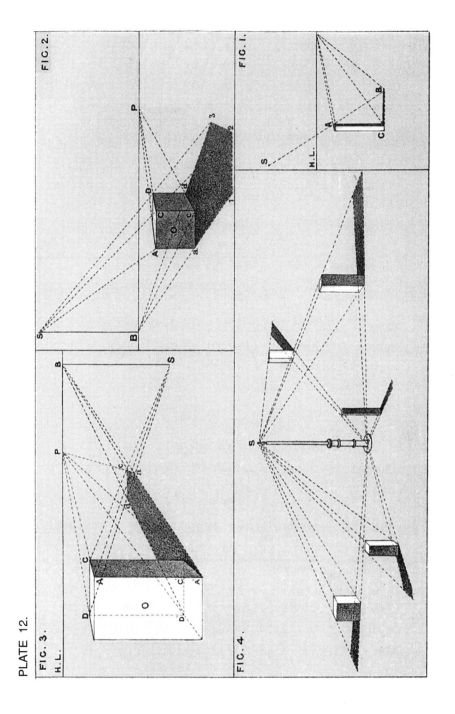

FIG. 1.

FIG. 2.

FIG. 3.

FIG. 4.

The cube and parallelopiped are the model on which houses, boxes, books, beds, chairs, and various articles of furniture are formed. The triangular prism may be discerned in the roofs of houses, in flights of stairs, in tents, in desks.

Hexagonal prisms in the cells of bees.

Octagonal prisms in columns.

In steeples and obelisks are discerned the pyramids.

In round towers, stems and branches of trees, columns, the bodies and limbs of men and animals, in bottles, and in some vegetables, we recognize the cylinder.

The sphere can be detected in the heads of children, in globes, lamp-glasses, bowls, domes, fruit—such as apples, oranges, peaches, nectarines, apricots, cherries, currants, grapes, and vegetables—such as onions.

In the heads of adults, in eggs, in fruit—such as plums, nuts, grapes, dates, gooseberries, and in gourds and cabbages may be traced the oval.

To the cone are referred the tops of certain towers in France and Germany, extinguishers and sugar loaves, various species of flowers—of fruit, the pine-apple, fig, pear, raspberry, strawberry, mulberry, and blackberry—and of roots, carrots, parsnips, and turnips of some kinds.

The person who can draw accurately the above-mentioned simple geometrical forms will have but little difficulty in making a correct representation of any of the objects in this list. The true principles on which the expression of the form by means of light

and shade is based having been learned from the white models, the natural colours of the real objects will no longer be found perplexing; and the gratification arising from the consciousness of having acquired the power of drawing from nature will amply compensate for the labour and time bestowed on it. Thus will the diligent student have made some progress in the acquirement of "the form of expression of a universal language, which bears the same relation towards visible objects that writing does to thought."